CONTENTS

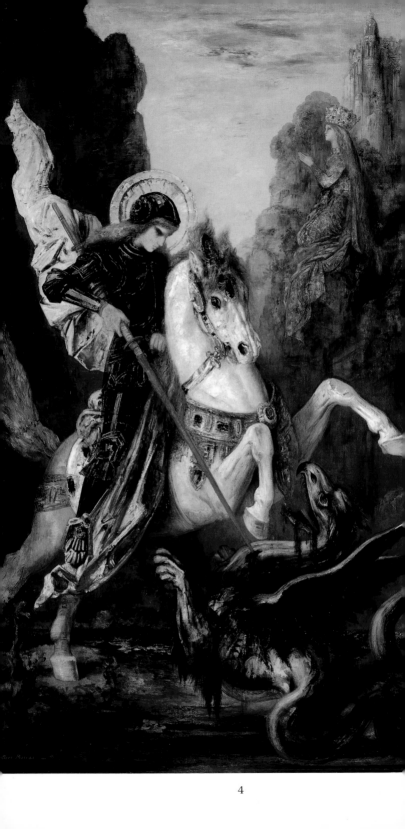

FOREWORD

The National Gallery contains one of the finest collections of European paintings in the world. Open every day free of charge, it is visited each year by millions of people.

We hang the Collection by date, to allow those visitors an experience which is virtually unique: they can walk through the story of Western painting as it developed across the whole of Europe from the beginning of the Renaissance to the end of the nineteenth century – from Giotto to Cézanne – and their walk will be mostly among masterpieces.

But if that is a story only the National Gallery can tell, it is by no means the only story. The purpose of this series of *Pocket Guides* is to explore some of the others – to re-hang the Collection, so to speak, and to allow the reader to take it home in a number of different shapes, and to follow different narratives and themes.

Christian saints, and the angels who flit through so many of the earlier works in the Gallery, shed light not only on the meaning of individual pictures but also on the functions of religious art in European society. Colour, that fundamental ingredient of painting, is shown to have a history, both theoretical and physical – and Impressionism, perhaps the most famous episode in that history, is revealed to have been less a unified movement than a willingness to experiment with modern materials and novel subject matter.

These are the kind of subjects and questions the *Pocket Guides* address. The pleasures of pictures are inexhaustible, and our hope is that these little books point their readers towards new ones, prompt them to come to the Gallery again and again and accompany them on further voyages of discovery.

Neil MacGregor
DIRECTOR

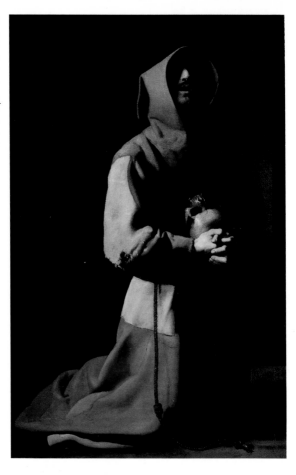

INTRODUCTION

RECOGNISING SAINTS

If you enjoy looking at pictures, you may also have, as I do, a soft spot for paintings of saints – whether or not you believe in the saints' special status, their power to intercede with God on our behalf. To walk for the first time into an art gallery or a church, and recognise Saint Catherine of Alexandria with her wheel [2] or Saint Francis of Assisi in his patched friar's tunic [1] is as comforting as running into old friends. And finding them alongside unfamiliar figures

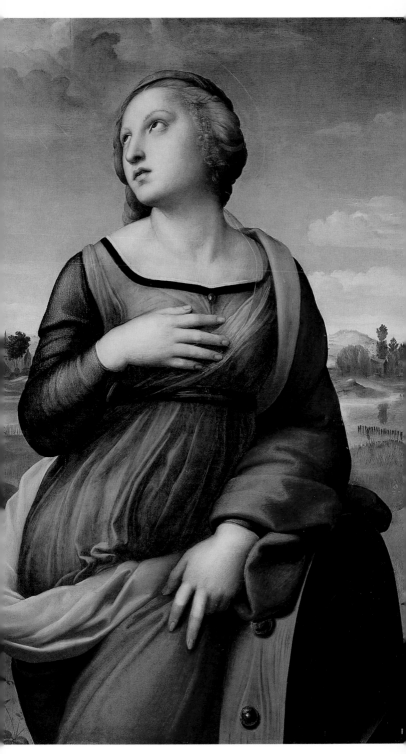

like Bishop Emidius, patron saint of Ascoli Piceno in the Italian Marches [3], is like going to the best kind of party, where you know many people but also have the chance to meet new ones.

The purpose of this *Pocket Guide* is not, however, to introduce all, or even most, of the saints. They are listed in many dictionaries, and their stories can be found in anthologies of saints' lives. The most popular of these, and the one most often relied on by artists, was *The Golden Legend*, written about 1266 by Jacobus de Voragine, Dominican friar and Archbishop of Genoa.

The aim of this book is rather to give a short account of how and why the imagery of saints evolved: who commissioned pictures of saints, how and by whom they might have been viewed, and how they

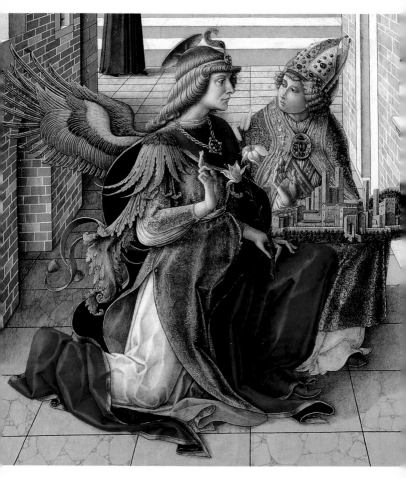

might have influenced attitudes to images in general. Such a small book on such a large subject must by definition be sketchy, and some of it is inevitably speculative and subjective. But one of the great pleasures of old master paintings is that they have gathered centuries of viewing; when we look attentively enough, our gaze mingles with the gazes of long-dead viewers. Although strict historical reconstruction is impossible, I would like to share with you that sense of empathy with the past that I particularly cherish when looking at pictures of saints – probably the most looked-at images in European history.

4. Hans Memling, *The Donne Triptych*, probably 1478. 70.7 x 70.5 cm. Detail of Saint Catherine

Since Christian saints are meant to be honoured throughout the Catholic Church, their images have always needed to be universally recognisable, which is why they became so standardised. While there may be little scope for originality in the way saints are represented, there is often room for pictorial wit, a gentle teasing of the viewer. In Hans Memling's *Donne Triptych* [4] the female saint on the extreme left holds the sword with which, according to legend, she was beheaded. As many holy women were

5. Adam
Elsheimer,
*Saint Lawrence
prepared for
Martyrdom*,
about 1600–1.
26.8 x 20.8 cm.

killed in this way, it is only when we find the mill wheel in the distance that we can identify her as Saint Catherine.

But who are the saints, and why are they shown with objects like the wheel and the sword, which serve as their attributes, or pictorial identity tags?

THE MAKING OF
SAINTS I

MARTYRS AND CONFESSORS

In the Judaeo-Christian tradition, saints, or 'holy ones', are not merely good, pious people. Nor are they necessarily mystics blessed with visions, or miracle-workers, although miracles have become a benchmark of sainthood. They are heroes for God. The first Christian saints – if one excepts the Virgin Mary, John the Baptist and the Apostles – were the martyrs, put to death because, refusing to sacrifice to the pagan gods of the Roman state religion, they were viewed as politically subversive. The word martyr means witness, and these witnesses to their Christian faith were specially honoured for their devoted imitation of Christ, who suffered and gave his life as a witness to God's love of humanity.

The earliest record of the cult of a martyr is a letter from the Christians of Smyrna describing the martyrdom of their bishop Polycarp in about the year 156 AD. After his body had been burnt, they collected his bones, 'more precious than jewels' and buried them in a safe place where, 'with the Lord's grace', they could assemble 'to celebrate joyfully the feast-day of his martyrdom'. The celebration would have been joyful because a martyr's death marked victory over death itself: the assurance of immortality in Heaven, in close proximity to God's throne.

Just as the pagans awarded palm branches to victorious athletes, so Christian imagery often awards palms to martyrs. In Adam Elsheimer's *Saint Lawrence prepared for Martyrdom* [5], one of God's angelic messengers, visible only to Lawrence, swoops down from the skies to present the young martyr with his palm. To demonstrate that they are 'unbelievers', Lawrence's persecutors are shown wearing exotic clothes. Their commander is dressed like a Turk, while the costume of the man on the left recalls that of a sixteenth-century German, and may be meant to suggest a Lutheran Protestant. In a final bid to save Lawrence's life, a bearded old man, hooded in black like a Roman priest, urges the saint to worship a

stone idol. The ruins in the background are those of ancient Rome. According to legend, Lawrence, a young archdeacon of the Church, was martyred in Rome around the year 258 AD by being roasted on a gridiron – shown in the middle distance with half-naked executioners stoking the raging fire beneath it.

If we know Saint Lawrence's story from having heard it told or read it in *The Golden Legend*, we can easily grasp the subject of Elsheimer's narrative picture. Nor should we have much greater difficulty recognising the image of Saint Lawrence in other contexts. The Netherlandish painter Memling [6] represents him without his martyr's palm, giving him a book instead; yet who else but Lawrence could be depicted as a youth in the liturgical dress of a deacon, holding a gridiron?

These same attributes help us to recognise him as the saint chatting to Saint Francis in a picture by the Italian friar, Filippo Lippi [7, 23].

Catherine of Alexandria was another third-century martyr, and, like Lawrence's gridiron, her wheel and sword recall

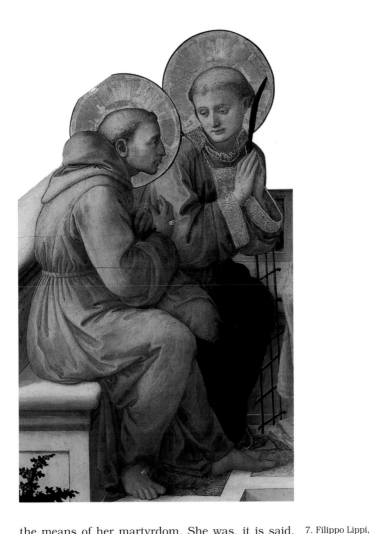

the means of her martyrdom. She was, it is said, ordered to be torn to death between spiked wheels. When a burst of fire from Heaven destroyed the wheels, she was decapitated with a sword instead. Even those totally ignorant of her story commemorate both martyr and miracle in the name of a firework, the 'catherine wheel' – and a wheel is the clearest pictorial sign by which we identify her image.

Catherine's legend also recounts a vivid dream she had when she was baptised into the Christian faith. In this dream, the Christ Child on his mother's lap took Catherine to be his celestial bride, slipping a ring on her finger as a token of their mystic marriage. Even though this event long preceded Catherine's martyrdom, Parmigianino includes the spiked wheel

13

in the foreground of his *Mystic Marriage of Saint Catherine* [8]. Indeed, it would seem that the arc and spokes of Saint Catherine's attribute inspired the entire composition: from the round window – whose vertical glazing bar implicitly bisects the whole painting, focusing our gaze on where Christ's and Catherine's hands meet – through the graceful two- and three-dimensional curves in which the figures are posed and the drapery falls.

As we can infer from the letter about the cult of Bishop Polycarp, sanctification of early Christian martyrs was a spontaneous reaction of the Christian communities in which they had lived. Martyrs' feast-days would have been celebrated near their tombs with a communal meal in commemoration of the Lord's Supper. After 313 AD, when Christian worship was legalised throughout the Roman Empire, these meals became the church service of Holy Communion. The martyrs' precious remains were reburied under, or in, the altars at which communion was administered:

> *The glorious victims take their place where Christ offers himself as a victim. He who was put to death for all is on the altar; those who have been redeemed by his suffering are under the altar.*

These words were written by a fourth-century bishop, Ambrose of Milan, who was himself later declared to be a saint. By this time, bishops had taken it upon themselves to verify the credentials, and sanction the veneration, of martyrs. The precaution was justified: a congregation near Tours had been found worshipping at an altar beneath which were buried the bones ... not of a witness for Christ, but of an executed brigand.

This misplaced zeal was discovered by another fourth-century bishop, Martin of Tours, now better known as Saint Martin. He belongs to another early category of saint: the 'confessor'. Confessor saints are not those who hear the confessions of others, but those who confess – that is, bear public witness to – their faith. They endure heroic hardships and perils, sometimes through persecution, at other times through ascetic practices, but are not actually put to death.

It was obviously harder for artists to assign a pictorial attribute to a confessor than to a martyr –

but Saint Martin's early history suggested an unam-
biguous identifying emblem. He was a soldier before
he became a priest. One cold winter day, he rode by a
beggar who was dressed only in rags and suffering
from the bitter weather. Martin took out his sword,
cut his warm cavalry cloak in two, and gave half of it
to the beggar. That night he dreamt that Christ

8. Parmigianino,
*The Mystic
Marriage of Saint
Catherine*,
about 1527–31.
74.2 x 57.2 cm.

9. Gerard David,
*Canon Bernardijn
Salviati and
Three Saints*,
after 1501.
103.4 x 94.3 cm.

10. Detail of
Saint Martin
and the beggar

appeared to him, saying: 'What you have done for that poor man, you have done unto me.'

It was not this somewhat tepid good deed which earned Martin sainthood, but rather the total of his life in the service of Christ. Yet because the story is unique to him, he is usually depicted on horseback, cutting his cloak in half, with a small ragged beggar in tow. But this is not how he appears in a fragment of the altarpiece commissioned by Bernardinus de Salviatis for the Collegiate Church of St Donatian in Bruges [9].

Bernardinus, a canon of the church, had himself portrayed kneeling at prayer, looking towards the cross on the altarpiece's right-hand panel (probably a *Crucifixion* now in Berlin). He wears the vestments of

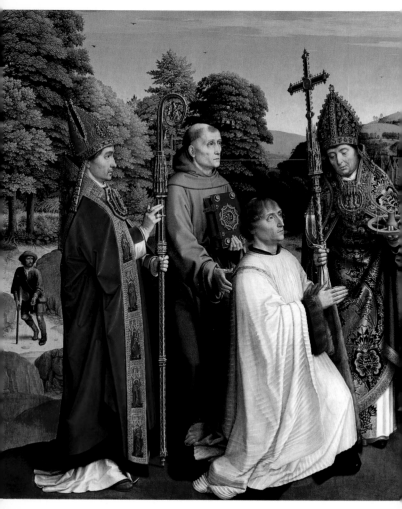

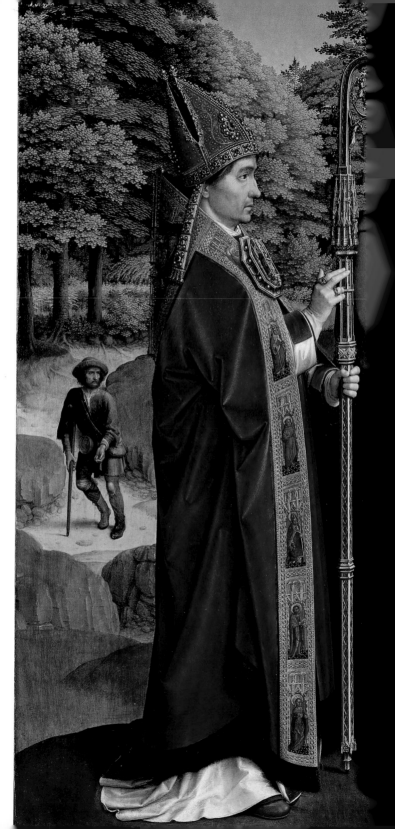

his office: a black cassock edged with brown fur, and over it a pleated white tunic, the rochet. On his left arm he carries an almuce, or hooded cape, of grey fur. Bernardinus is being presented to Christ by his name saint – the saint whose name he was given at baptism – the Franciscan preacher Bernardino of Siena (1380–1444). On the right stands the titular saint of the church and patron saint of Bruges, Donatian, a fourth-century bishop and martyr. Dressed in arch-bishop's vestments contemporary with the painting, Donatian holds his emblem of a wheel set with five candles. According to legend, such a wheel was floated down the river into which he had been thrown. It stopped over the spot where his drowned body lay, and he was recovered and brought back to life by prayer.

It would have been unseemly, in this solemn ecclesiastical company, to introduce Saint Martin as a soldier – nor would the format of the panel have allowed him to appear mounted on his horse next to the other figures.

Gerard David therefore depicts Martin as a bishop, but gives us two clues to his identity. The very sharp-eyed viewer might just make out that his morse – the jewelled clasp of his red velvet cope – is set with a scene of a man cutting his cloak in half to give to a crouching beggar [10]. For those of us with merely normal eyesight, David has painted a beggar in the landscape behind the holy bishop – a beggar in whom we recognise the saint's attribute, just as we recog-nise Saint Catherine's wheel in the mill wheel in the background of Memling's *Donne Triptych* [4].

11. Lucas Cranach the Elder, *Saints Genevieve and Apollonia*, 1505–8. 120.5 x 63 cm. Detail of Saint Genevieve

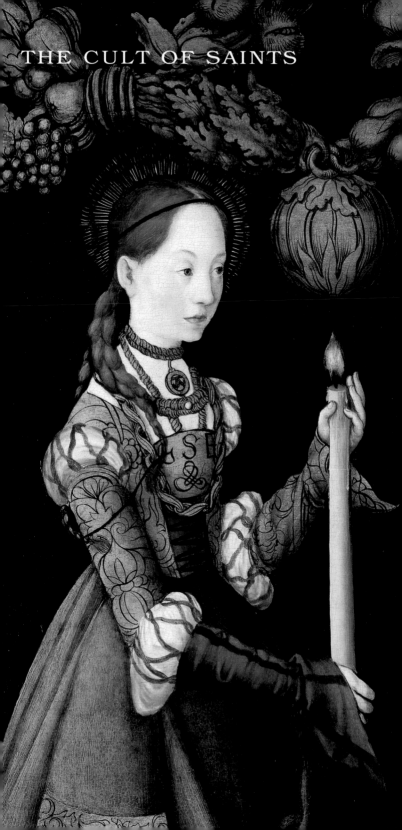

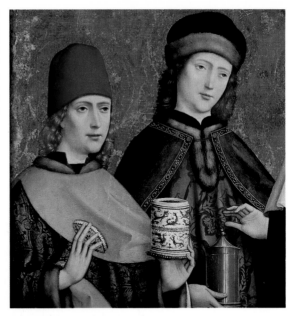

RELICS AND IMAGES

Early Christians, gathered around the tombs of
local martyrs and confessors, venerated these
witnesses to the faith through their relics – the saints'
physical remains or objects they had touched – not
their images. They would have been amazed at the
paintings reproduced here. Relics came to be
regarded as offering protection against misfortune or
ill-health, or as agents of healing; some appeared to be
more efficacious than others. Once saints' relics were
'translated', that is removed from tombs to altars, they
could be divided, split into fragments – increasingly
so as churches and altars proliferated. Competition
between churches and shrines, and a brisk trade in
relics, ensued, because effective relics attracted both
pilgrims and trade. As local cults of martyrs and con-
fessors spread further afield, means had to be found
of identifying which saint was connected with what
altar. Images of saints might be said to have originated
as illustrated labels, indicating the titular saint in
whose memory Christ's sacrifice was re-enacted at a
particular altar. In due course, these images became
banners to which people rallied, defining their own
identity and allegiances through their choice of patron
saints, whose pictures they carried in processions.

By the second millennium, European society was recovering from the barbarian invasions and civil wars that had destroyed the Roman Empire. Monastic orders had cleared new tracts of countryside for agriculture. Cities were founded or expanding, and within them associations of artisans and merchants were formed. Dioceses – districts under the jurisdiction of a bishop – were subdivided into parishes. Parishes spawned benevolent confraternities, whose members were joined in devotional practices and good works. Early Christian communities had sheltered around their martyrs and confessors, and individuals were placed under the protection of saints in whose name they were baptised [9]. Each of these new institutions required its own saintly advocate and to this end, centuries-old local cults were promoted or revived. Cities often chose as their patron their first, martyred bishop, like Saint Emidius who holds a model of Ascoli Piceno in Figure 3, or Bruges' Saint Donatian in Figure 9. Paris gallantly adopted Saint Genevieve, the fifth-century heroine of a siege by barbarian Franks and Huns [11]. The fourth-century doctor-martyrs, Saints Cosmas and Damian, became the patrons of doctors and hospitals [12], while painters venerated Saint Luke, evangelist, physician and legendary portraitist of the Virgin Mary [13]. But new institutions also felt the need for new saints. Monastic orders naturally put forward

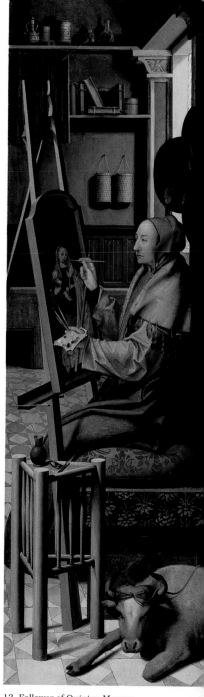

13. Follower of Quinten Massys, *Saint Luke painting the Virgin and Child*, about 1530. 113.7 x 34.9 cm.

14. Detail of 16, Saint Bernard

15. Master of Liesborn, *Saints John the Evangelist, Scholastica and Benedict,* probably 1470–80. 55.9 x 70.8 cm.

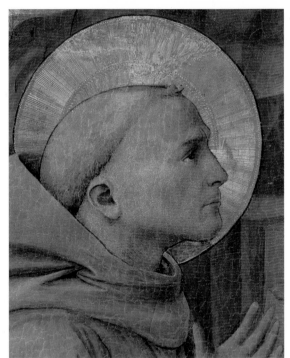

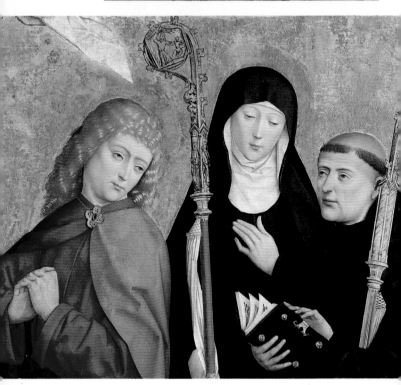

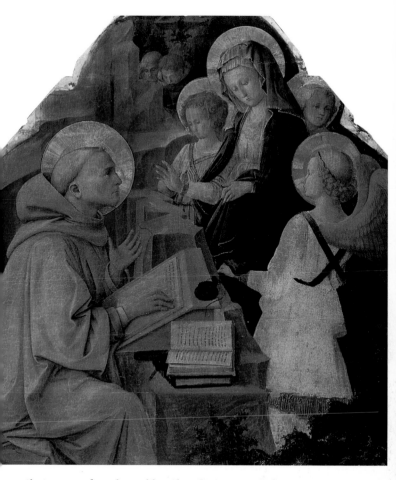

their own founders, like the Cistercians' Saint Bernard of Clairvaux [14, 16], or the Benedictines' Saint Benedict and his sister Saint Scholastica, shown here with Saint John the Evangelist [15]. As more religious orders were created, their founders too would be candidates for sanctification. Mystics and visionaries, charitable royals, ascetic nuns, charismatic preachers, all had their devotees. By the fifteenth century, when portraiture from life had become commonplace and casts were made of the faces of the illustrious dead, images of newly made saints became recognisable not only through their attributes but also through their likeness.

Bernardino of Siena, declared a saint shortly after his death in 1444, had been famous for promoting the adoration of the name of Jesus, in the form of the Greek monogram IHS, transcribed into Latin as *Iesus*

16. Filippo Lippi, *Saint Bernard's Vision of the Virgin*, 1447. 98 x 106 cm.

Hominum Salvator, Jesus Saviour of Mankind. This monogram, along with his grey Franciscan habit and his friar's tonsure, became Bernardino's attribute. The Netherlandish painter, Gerard David, relies on it to identify the saint in Canon Bernardinus's altarpiece [9, 17]. The better informed Italian Moretto, however, also gives Bernardino sunken cheeks and grey hair, approximating the preacher's appearance at the time of his death [18]. The National Gallery does not house any closer likeness of the saint, but any traveller in Bernardino's native Tuscany will instantly recognise the old man's toothless face in countless pictures based on his death mask moulded in plaster.

18. Moretto, *The Madonna and Child with Saint Bernardino and other Saints*, about 1540–54. 355.6 x 232.4 cm.

19. Guercino,
*Saint Gregory with
Saints Ignatius
Loyola and
Francis Xavier*,
about 1625–6.
296 X 211 cm.

In the same way, Lombardy is chock-a-block with images of the sixteenth-century archbishop of Milan, Charles Borromeo, declared a saint in 1610, and identifiable by his prominent aquiline nose and five-o'clock shadow. Charles's friend and adviser, the white-haired and bearded Philip Neri, founder of the Oratorians and declared saint in 1622, is equally recognisable, as are the Jesuit saints Ignatius Loyola (left) and Francis Xavier, shown here on either side of Saint Gregory the Great [19]. Portrait-based images like these not only aid identification, but also foster that sense of friendly intimacy with the saints as real and familiar people.

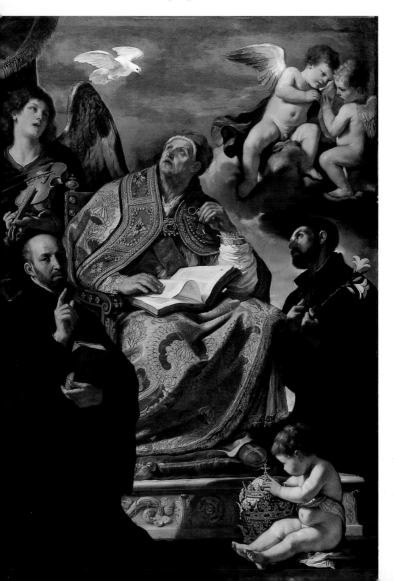

19. Guercino, *Saint Gregory with Saints Ignatius Loyola and Francis Xavier*, about 1625–6. 296 X 211 cm.

THE MAKING OF
SAINTS II

CANONISATION
AND BEATIFICATION

By the end of the tenth century, the growing prestige of the popes – Bishops of Rome, successors of Saint Peter and Christ's vicars – led Christian congregations and their bishops to seek papal ratification of the translation, or reburial, of relics from tombs to altars. The pope's approval of a local saint's cult enhanced its status, and abuses, like the fourth-century veneration of a bandit (page 14), also made people mistrustful of the more informal traditional procedures.

The first record of papal intervention in the cult of saints dates from 993, when Bishop Liutolf of Augsburg presented, to a Church council in Rome, a book recording the life and miracles of his predecessor, Bishop Ulrich (d.973). The council having been favourably impressed, Pope John XV issued a bull – a binding papal document – ordering the solemn veneration of Ulrich's memory. Circulated throughout France and Germany, this is the first known 'bull of canonisation', although the word 'canonisation', meaning formal admission to the Church's roster of saints, did not come into use until later.

However, for some long time, bishops continued to exercise their prerogative of translating relics and instituting cults, while increasingly turning to Rome for canonisation. The transition from episcopal translation to papal canonisation is nicely illustrated through the posthumous fate of two royal English saints [20]. Edmund, last king of East Anglia, was in 870 AD killed with arrows by invading Danes for refusing to abjure his Christian faith. Having become the object of veneration, his remains were moved around 915 to the church of the Benedictine abbey which later became known as Bury St. Edmunds. Edward the Confessor, last Anglo-Saxon king, died in 1066, having promised the succession to his cousin William of Normandy. His canonisation in 1161 by Pope Alexander III may have had as much to do with

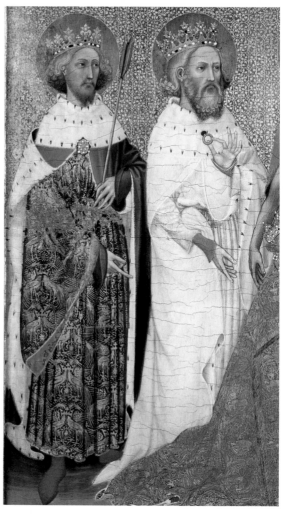

Alexander's gratitude for William's support against
the German Emperor, Frederic Barbarossa, as with
Edward's own monkish virtues.

Gradually, the balance of power in the making
of saints shifted in favour of papal authority. In
1234, during the papacy of Gregory IX, the exclu-
sive right of popes to canonise was inscribed in the
laws of the Roman Church. Papal commissions
were appointed to investigate the life and miracles
of candidates, and legal requirements for sanctity
were established. The examination resembled – and
continues to resemble – a legal trial, with advo-
cates, sworn witnesses and a prosecuting counsel,
popularly known as the Devil's Advocate, charged

with opposing attempts at canonisation by all lawful means. In theory, the papacy also reserved for itself the right to approve local cults, observed within a single diocese. Such 'beatification', from the Latin word for 'blessing', has become a normal prerequisite for canonisation, although canonisation is not an inevitable consequence of beatification.

In practice, local cults, such as that of Saint Edmund, continued to flourish and even to multiply without papal consent. The words 'blessed' and 'saint' were for a long while applied without distinction to all those who were venerated, whether canonised or not. Despite protests by some, images continued to be erected to both. Indeed, images, because they attracted the devout to altars and shrines, came to be used as arguments for canonisation. Artists tended to endow both blessed and saints with haloes – a zone of light around the head that had from time immemorial been the visual attribute of gods and saints. By the second half of the fourteenth century, however, a firmer distinction had been made. Circular haloes were reserved for saints, while the blessed were to be adorned merely with rays of light [21].

21. Carlo Crivelli, *The Vision of the Blessed Gabriele*, probably about 1489. 141 x 87 cm. Detail

Nonetheless, the rapid increase of new cults led to fears that the true faith was being diluted. The Florentine writer Franco Sacchetti (1330–1400) complained in a letter to a friend that the various religious orders, greedy for alms and offerings, were erecting so many altars to celebrate 'new saints' that belief in the 'old ones' was undermined:

> Who can assure that there are not many who suspect that the old saints began in the same way; the rays around their head and the inscription 'blessed' at their feet may in time have been converted, the rays into haloes, and the blessed into a saint? How can we believe in these our priests, who elevate the body of these Blessed so high, and there put candles and images; while Our Lord and the Virgin Mary are painted low, near the floor and in the dark without any light? ... And not long ago I saw in a row of five paintings three Saints and two Blessed... and the Pope does not attend to it, he has better things to do.

Sacchetti's scruples resemble those of sixteenth-century Protestant Reformers, who saw the veneration of saints as detracting from the worship of Christ. Today, even some Roman Catholics are perturbed by Pope John Paul II's unprecedented partiality for canonisation, and disapprove of his choice of new saints. Throughout the history of the Western Church, the making and unmaking of saints has always been a controversial matter, revealing tensions and conflicts between local interests and central power, between religious orders and regular clergy, between clergy and laity, scholarship and popular piety. Many patriotic Englishmen and women – by no means all Roman Catholics, or even believing Christians – were distressed when a recent papal reform removed Saint George, patron of England, from the Roman Calendar, demoting him from martyr to pious legend. But if he is no longer venerated at Catholic altars, his image survives, encouraging us to fight the good fight, and vanquish evil's dragon [frontispiece, 22]. It is his image, and not his cult, that has made Saint George famous, a glamorous emblem and role model of chivalrous courage and faith.

22. Paolo Uccello, *Saint George and the Dragon*, about 1460. 56.5 x 74 cm. Detail

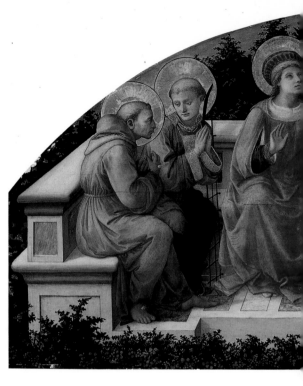

SAINTS AND
DOMESTIC IMAGERY

PATRONS AND ROLE MODELS

By the late Middle Ages, the example, protection and advocacy of saints were invoked not only by communities, confraternities and guilds but also by families and individuals. The feudal or patron-client networks of earthly society were reflected in the relationships of the living with their saints, now in Heaven but more accessible, sometimes even more comprehending, than God himself. As we have seen (page 21), most infants were christened with the names of saints – often more than one, and sometimes appended to the name of the Virgin Mary, even for male babies: many Frenchmen are still called Pierre-François or Jean-Marie. People's 'name days', the days of their name saints in the liturgical calendar, were celebrated more readily than their birthdays.

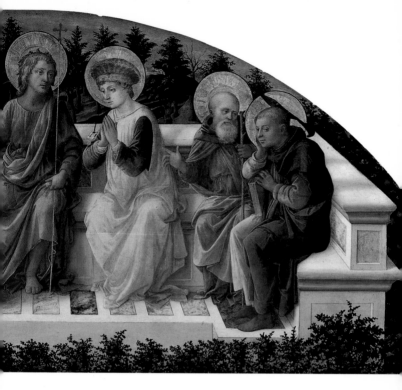

This was not merely because saints' days, normally the anniversaries of their death, were publicly observed and therefore more easily remembered: it was also a mark of Christian faith. As an early fifteenth-century cleric wrote in a sermon honouring Saint Jerome on his feast-day of 30 September,

> For if blind antiquity was accustomed to celebrate the birthday of human beings, the day on which they were conducted into this miserable life where needs of every sort abound, how much the more should we who are illumined by true faith treasure the feast-day of God's saints, the day on which they are conveyed into a life free from death, safe from catastrophe, and immune from all adversity!

The bond with one's own name saint was naturally more intimate than that with other saints; in addition to 'Christian name' saints, special allegiances to particular saints were forged through family names.

All this was naturally reflected in the production of images. By the fifteenth century, most Christian

23. Filippo Lippi, *Seven Saints*, about 1450–3. 68 x 151.5 cm.

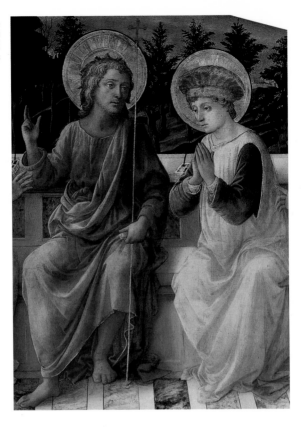

homes in Europe would have had at least one picture
of a particularly revered saint, from a cheap woodcut
bought at a fair to specially commissioned works by
leading artists – like Filippo Lippi's *Seven Saints*,
probably dating from the mid-1450s [23, 24, 7]. The
shape of this panel, once part of the furnishings of the
Palazzo Medici in Florence, suggests that it may have
been set over a door. The picture is thought to have
been commissioned from the Medici's favoured
painter by either Piero di Cosimo de'Medici (1414–69)
or his cousin, Pierfrancesco di Lorenzo di Giovanni di
Bicci de'Medici (1430–77). (Like the Anglo-French
prefix 'Fitz', 'di . . . ' means 'son of . . . '.) All these
forenames are names of saints, each of whom appears
here. Filippo was given the challenging task of design-
ing a coherent composition of seven male figures,
associated only through their names' importance to
the Medici dynasty.

His solution may have been inspired by the kind of
Renaissance altarpiece known as a *sacra conver-*

34

sazione, in which the Virgin Mary, enthroned with the Christ Child, is surrounded by saints, all seemingly communing together. Here, in the absence of the Virgin Mary, the earliest and most important of the Medici name saints, Giovanni Battista, John the Baptist, also a patron saint of Florence, sits in the centre of a stone bench that accommodates all the figures and subtly echoes the shape of the panel. Pointing upwards, he bears witness to the key event of his life, when he perceived the Holy Spirit descending upon Jesus at the Baptism: 'And I saw, and bare record that this is the Son of God' (John 1:34). He is flanked by two saints in doctors' robes and caps; one looks up to heaven in wonder, the other prays. These are the brothers Cosmas and Damian, the charitable early Christian doctors and martyrs, patrons of the family whose name, Medici, means physicians in Italian. Beside them sit Saint Lawrence (Lorenzo), with his gridiron, and the elderly hermit Saint Anthony Abbot (Antonio). Lawrence's hands are folded in prayer, but his eyes are fixed on the radiant wounds in the hands of Saint Francis (Francesco), miraculously replicating those of the crucified Christ. Anthony, echoing the Baptist, turns to Peter (Piero) – not the apostle Saint Peter but the Dominican preacher named after him, Saint Peter Martyr, who listens meditatively. His attribute, a cleaver permanently fixed in his head, refers to his own martyrdom at the hands of heretics.

Filippo has related these figures to each other visually, and, more importantly, psychologically; and he has related them in a quite particular way to the original viewer or viewers. These male saints inhabit a world somewhere between Heaven and Florence. Like any respectable Florentine citizens – that is, men and property owners – of a certain age and gravity, they meet on a garden bench to discuss matters of common interest. But their conversation is not of politics, or business, or errant children and grandchildren. They address questions of eternal and universal import: Christ's divinity; bearing witness for one's faith; the need for charity, for meditation and prayer. Images of saints in the home not only provide a focus for devotion; they are there to remind viewers daily of the spiritual dimension of their lives.

Yet saints could also be enlisted as role models to

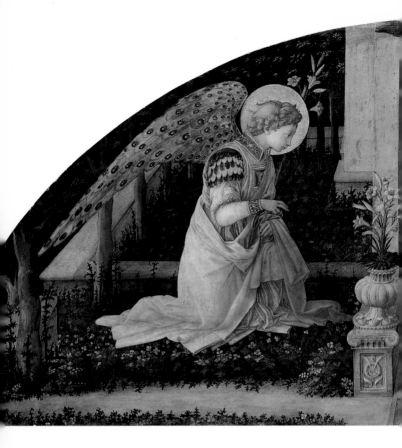

25. Filippo Lippi,
The Annunciation,
about 1450–3
68.6 x 152.7 cm.

enforce secular social ideals. In the companion panel of the Annunciation, also by Filippo Lippi and possibly intended for the room of a female member of the family [25], the Virgin Mary submits to God's will: 'Behold the handmaid of the Lord; be it unto me according to thy word' (Luke 1:38). Holiest of the saints, Mary has been sitting alone in her bedroom, reading a prayer book. The Archangel Gabriel's appearance, in the enclosed garden which symbolises Mary's virginity, also signifies the moment of the miraculous conception of her Child. A scattering of gold rays emanates from her womb to meet the dove of the Holy Spirit launched from the top of the panel. The male Medici name saints John, Cosmas and Damian, Lawrence, Anthony, Francis and Peter Martyr are pictured in company, conversing. Filippo's image of Mary reflects the other side of the coin: the Florentine Renaissance ideal of a retiring, chaste, devout, submissive but fertile wife.

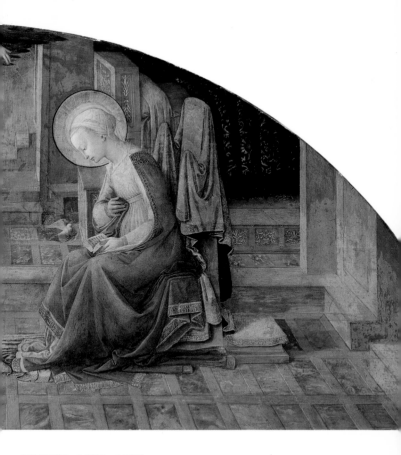

PIETY AND ART

Filippo's panels are beautifully painted and highly decorative, but I think we can assume that, to their Medici owners, their value as works of art was secondary to their social and religious functions. This need not have been true of all domestic images of saints.

Jerome (?347–420), monk and translator of the standard Latin version of the Bible, the Vulgate, became in the fifteenth-century a favourite subject of small pictures for the home. We cannot always tell how, or by whom, these paintings were meant to be viewed (not all the people who commissioned them can have been called Jerome). The question is complicated by the fact that images of Jerome tend to fall into one of two categories. The saint is shown either in penitence in the wilderness, as in Dürer's wonderful little panel of about 1495 [26], or as a scholar snugly installed in his study, as in Antonello da Messina's

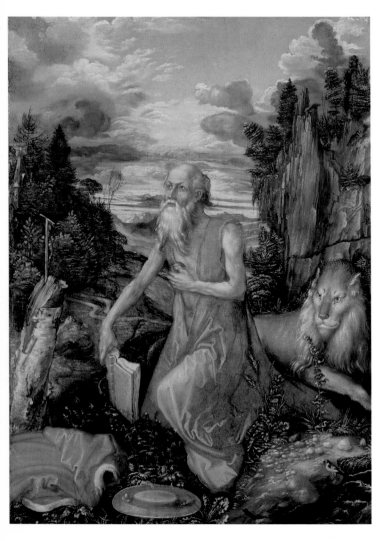

26. Dürer,
Saint Jerome,
about 1495.
21.8 x 16.1 cm.

equally magical, and only slightly larger, work of some twenty years earlier [27].

Both types of image are based on biographical fact and tradition. The office of cardinal did not exist in Jerome's lifetime, but as a papal adviser he is normally given a cardinal's red hat and cloak. Legend attributed to him another saint's good deed, extracting a thorn from a lion's foot, and he is normally pictured with a tame lion. Both types – Jerome as penitent and Jerome as scholar – originated as exhortations to the spiritual life, but their definitions of this differ. In the penitent version, Jerome beats his breast with a stone while contemplating a crucifix. Dürer shows him

38

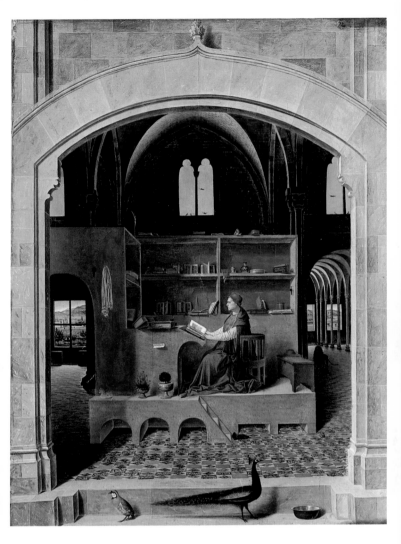

holding a book, which can only be the Bible. But a con-
temporary viewer would have known that before he
turned to collating and translating Scripture, Jerome
retired to the Syrian desert repenting of his earlier
devotion to pagan writers. This category of image – if
not Dürer's particular one – deprecates intellectual
achievement in favour of direct empathy with Christ,
and the emulation of his sufferings through penitential
practices. It is a view of Jerome, supposed founder of
Western monasticism, made popular in the newly
formed, ascetic Hieronymite convents (Hieronymus is
the Latin form of Jerome). Antonello's alternative, con-
versely, celebrates book learning, the transmission

27. Antonello da
Messina,
*Saint Jerome in
his Study*,
about 1475.
45.7 x 36.2 cm.

of the Word of God through written texts. While both versions elevate contemplation above action, they are diametrically opposed in their ideal of how the contemplative life should be lived.

Must we then suppose that Dürer's patron (or, if the painting was made for sale on the open market, the picture's buyer) was an anti-intellectual devoted to a life of penance, and that Antonello's was a studious theologian, claiming Jerome as patron of his academic endeavours?

The latter appears more probable, and a modern art historian has indeed suggested that Antonello has here portrayed a learned cardinal in the guise of Saint Jerome. The picture is, however, first recorded only in 1529, when it belonged to a non-clerical Venetian art lover. And a closer comparison of both paintings suggests that they may always have been intended rather more as works of art than as objects of piety.

Dürer's Jerome is a noble figure, but a stereotypic one: the freshest and most affecting passages of the picture are the descriptions of nature, from the vivid finches in the foreground [28], through the wooded crags to the snow-capped mountains on the horizon, the rising or setting sun warring against clouds. The pitched roof of a Gothic castle rises above oaks and firs; the lacy tracery of a dead tree is silhouetted against the sky [29]. Dürer's 'Syrian desert' is alive with vegetation, and the saint and his lion rest by the rippling waters of a swiftly running stream. Jerome's crucifix is wedged in the stump of a silver birch tree. Whatever their burden of religious symbolism, these details draw the eye through their exact and poetic evocation of the visible world, as Dürer had experienced it on his momentous voyages across the Alps. Holding this tiny picture in the hand and gazing into its depths as in a crystal ball, its owner could undertake a journey of the imagination, sharing the artist's wonder and delight in the the capacity of art to recreate the plenitude of God's creation.

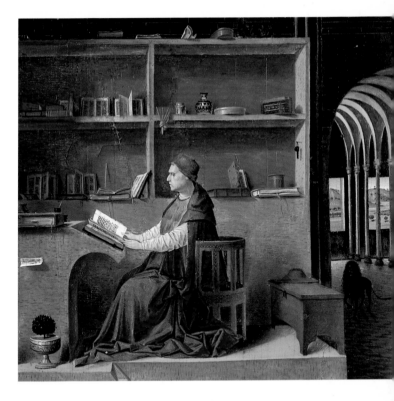

Antonello's impassive and immobile Saint Jerome, absorbed in his book, is more remote from the viewer than Dürer's. Not content with recreating remembered experience, the painter has imagined a fantastical interior, part-church, part-palace, part-library. But this artificial setting is animated by what appears to be real light moving through real space and casting real shadows. One light source originates in the viewer's own space in front of the picture – as if our gaze, entering through the large opening in the stone façade, itself illuminated the scene within [30]. But sunlight also streams in through windows deep within the painting; beyond them the sky is alive with birds, there are fields and mountains, a minuscule walled city, a river, people boating or fishing – vistas receding to the horizon and seeming to continue beyond [31]. Even more than Dürer, Antonello demands the viewer's active collaboration: the harder we look, the more we see. In an age before photography, when even mirrors were scarce, this level of representational skill would have seemed little short of miraculous.

Both these works evoke religious sentiments, but

30 and 31.
Antonello da
Messina,
Saint Jerome in his Study,
about 1475.
Details of 27.

43

they are above all – and surely always were – a source of aesthetic pleasure. The growing demand for domestic images of saints ultimately led the affluent classes to value the craft of painting itself, especially for its ability to represent in two dimensions the appearance of a three-dimensional world. Where an earlier generation of the wealthy had amassed objects in rare and costly materials, by the late fifteenth century their descendants had learned to prize artistic skill above material value, and had begun to collect pictures by the best and most innovative painters.

The conflation of piety with visual enjoyment was not confined to the rich and sophisticated, as an anecdote in Vasari's *Life* of his contemporary, Michelangelo, suggests. Vasari records the great artist's affection for a rustic itinerant painter who made crude little pictures of saints to sell to Tuscan country people. One of this man's anecdotes which most amused Michelangelo concerned a peasant who had ordered an image of Saint Francis of Assisi. He was dismayed that the saint's habit, adopted by Francis as a symbol of humility and poverty, was so dull and sad in colour. To please him, the painter gave Francis a richly decorated priest's vestment, although the saintly friar had only been a deacon and was never ordained, and the peasant went away happy with his picture. Similar considerations may have prompted Botticelli to set the drab figure of the saint against a gold-leaf background and surround him with multicoloured angels [32].

But where precisely, the modern gallery visitor may wish to ask, did piety end and aesthetic appreciation begin? We tend now to believe that the two are distinct, yet in past ages the question may never have arisen. The Tuscan peasant wished both to have a bit of beautiful bright colour on his wall and to honour his favourite saint. An innovative artist wanted to show off his powers, but this does not mean that he treated the subject of his painting cynically. An owner/viewer may sometimes have turned to a saint's image for comfort and edification, and at other times as one would to any picture, for pleasure, but mainly, one suspects, for both reasons simultaneously: spiritual refreshment. Most of us have lost this double viewpoint – perhaps because religion and the saints are no longer part of our daily lives and affections.

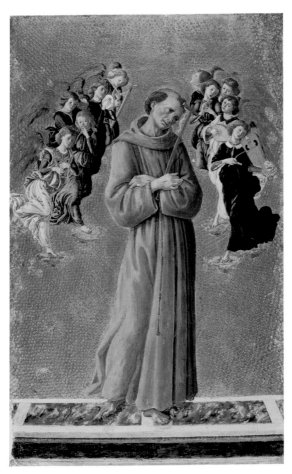

PRIVATE VIEWING
AND PUBLIC ISSUES

Yet another complicating factor in the private view-
ing of saints' images is that, just as they could be
used to enforce secular ideals (see page 36), so they
were also enlisted in contemporary controversies.

For the modern spectator, probably the most diffi-
cult picture of Saint Jerome in the Gallery is that
painted by Domenichino in about 1602, shortly after
his arrival in Rome from his native Bologna [33]. By
1603 it was in the collection of Cardinal Pietro
Aldobrandini, nephew of Pope Clement VIII.

Domenichino situates Jerome in a grotto-study in the wilderness, combining the two strands of the saint's imagery. He introduces two, more startling, novelties. The saint appears almost as naked, and every bit as muscular, as Michelangelo's monumental nudes in the Sistine Chapel. Jerome's work of biblical translation appears to be dictated to him by an angel – a detail which is associated with the imagery of the evangelist Saint Matthew, but is not part of the pictorial or biographical tradition of Jerome.

What is going on, and how was this – to us rather disagreeable – picture viewed? Has Domenichino confused Jerome with Matthew, and is he just showing off his newly acquired knowledge of Michelangelo? What was the painting's significance for Cardinal Aldobrandini?

By the end of the sixteenth century, the Vulgate, Jerome's Latin version of the Scriptures, had come under attack. Humanist scholars, better trained in Hebrew, Greek and Aramaic than Jerome, had discovered inaccuracies in his translation. Alternative texts were proposed, claiming greater fidelity to the Word of God. Protestants throughout Europe challenged Rome by producing translations in modern, spoken languages, so that the Bible, hitherto reserved for the clergy alone, could be read by everyone. The authority of the standard text used throughout the Roman Church, and the whole edifice of the Church with it, was undermined.

To defend Jerome and his translation was therefore to defend Catholic tradition, and papal supremacy itself. The Pope, prohibiting scholarly criticism and other translations, reaffirmed the Vulgate's authority.

And that, of course, is the prime meaning of Domenichino's picture for the Pope's nephew. Like the prophets of the Old Testament or the evangelists, Saint Jerome is divinely inspired; an angel, God's messenger, instructs him. The saint's nudity is symbolic, recalling – via Michelangelo – the divinities and heroes of pagan myth. Jerome has become a Hercules for Christ, labouring to purge Christendom of dissent and heresy just as Hercules laboured to cleanse the Augean stables.

PIETY AND GENDER

Reformers complained that the statues of female saints in churches were too beautiful and too richly dressed, more like courtesans than holy women. In the private sphere the potential for confusion could be even greater. Once again, the modern gallery visitor is at a disadvantage in trying to reconstruct the artist's original intentions and his contemporary viewers' responses.

The most popular female saints, such as Saint Catherine of Alexandria, were venerated equally often by women and men, and their imagery reflects this [2, 34].

On the other hand, we can well believe that a charming small picture of Saint Dorothy, probably designed in the 1460s by the Sienese artist, architect and engineer Francesco di Giorgio, was made for the devotions of a woman named Dorothy [35]. In many respects it resembles the somewhat later picture of Saint Francis in Figure 32: the saint is shown against a gold-leaf background. The effect, however, is even more decorative. Dorothy, a Christian virgin martyr put to death around 300 AD, is a graceful young woman, elegantly dressed and carrying a sprig of

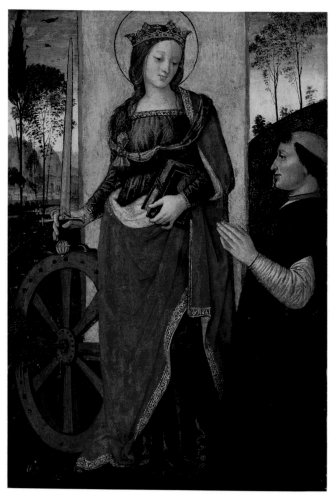

carnations. As she was being led to execution, legend has it, a pagan lawyer named Theophilus mocked her, asking her to send him flowers and fruit from the garden of Paradise. Miraculously, a heavenly child (here the Christ Child himself) appeared with a basket of apples and roses, which she had sent to Theophilus, who was converted to Christianity as a consequence and was subsequently also martyred.

We are spared the martyrdom and shown the miracle – the saint's identifying attribute – whose secular counterpart, the love and cultivation of flowers, was a suitable female accomplishment. The saint, patron also of brides and newly weds, was in every way an acceptable role model for a young woman, and the painting a welcome embellishment of any woman's chamber.

35. Associate of Francesco di Giorgio,
Saint Dorothy and the Infant Christ, probably 1460s.
33.3 x 20.6 cm.

36. Van Dyck,
*Lady Elizabeth
Thimbelby and
Dorothy,
Viscountess
Andover,*
about 1637.
132.1 x 149 cm.

Nearly two hundred years later, in 1637, Antony van Dyck painted the two married daughters of Thomas, Viscount Savage [36]. Elizabeth, standing on the left, had married Sir John Thimbelby, a notable recusant (a Catholic who refused to attend Anglican services) in 1634. In 1637 her sister Dorothy caused public scandal by eloping with the Catholic Charles Howard, Viscount Andover.

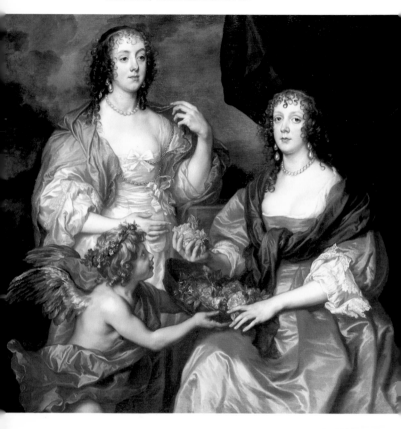

The painting is most obviously a double portrait celebrating the friendship of two sisters, on the occasion of the elder's marriage. To most educated English viewers of the period, the winged child may have seemed a Cupid bringing flowers to the bride – but the picture also has another meaning. To Van Dyck and his sitters, all three Catholics in an aggressively Protestant country, the winged child with his basket was the attribute of Saint Dorothy. Like Sebastiano del Piombo in the previous century [37] or Gonzales Coques some fifty years later [38], Van Dyck identifies

his sitter through the traditional visual clues to her name (Sebastiano's portrait shows the martyred Saint Agatha's breasts on a plate in the background, together with the shears used to cut them off; Gonzales Coques's lady caresses a lamb, in Latin *agnus*, punning attribute of Saint Agnes). But in its precise context Van Dyck's device suggests more. Dorothy, Viscountess Andover, assumes the identity

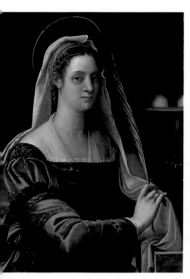

of Saint Dorothy; invoking the protection of her very own saint, she may also be declaring her readiness to suffer martyrdom (or at least social disgrace) for her love and her faith.

These works by Francesco di Giorgio, Van Dyck, Sebastiano and Coques in no way exclude male spectators, but all seem to have been primarily adapted to women viewers and sitters.

But what of the imagery of that most problematic female saint, Mary Magdalene? Her scandalous past, constructed by male theologians from various unconnected passages of the Bible, made her a dubious role model for unmarried girls, wives and mothers. Her later history, however, singled her out as the supreme Christian penitent and contemplative. The loving sinner, privileged to be the first to see the risen Christ, became in a sense a counterpart of his loving mother, the Virgin Mary. For many centuries, these two Maries together exemplified a male view of woman-

37. Sebastiano del Piombo,
Portrait of a Lady with the Attributes of Saint Agatha,
about 1540.
92.4 x 75.3 cm.

38. Gonzales Coques,
Portrait of a Woman as Saint Agnes,
about 1680.
18.3 x 14.4 cm.

39. Annibale
Carracci,
*The Dead Christ
Mourned ('The
Three Maries').*
about 1604.
92.8 x 103.2 cm.

hood, at the same time transcending gender to achieve universal relevance. But, unlike the Virgin's, the Magdalen's image may have been, I think, most often intended for the gaze of male spectators.

In the Gospels, Mary of Magdala was one of Jesus's women followers, who ministered to him as he preached in Galilee; he had healed her of demonic possession by seven evil spirits (Luke 8:1–2). She was present at his crucifixion. With two other women, she went to his tomb with spices to anoint his body, and found the tomb empty (Mark 16:1–8). It was to her that the risen Christ first appeared on the morning of Easter Sunday (Mark 16:9; John 20:11–18).

The Roman Church traditionally identified this Mary with Martha's sister, Mary of Bethany. After supper in honour of Jesus, who had raised their brother Lazarus from the dead (John 11:18–45), she 'took ... a pound of ointment of spikenard, very costly, and anointed the feet of Jesus, and wiped his feet with her hair' (John 12:3). Mary Magdalene was finally also conflated with the unnamed sinner, a 'woman in the city' who, in the Pharisee's house, also

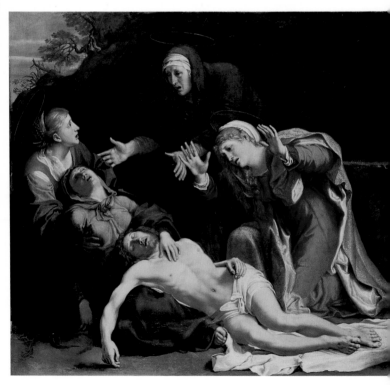

anointed Jesus's feet with her hair, her tears mingling with the costly ointment she brought in an alabaster box. It is of her that Jesus said, 'Her sins, which are many, are forgiven; for she loved much: but to whom little is forgiven, the same loveth little' (Luke 7:37–50).

This composite Mary Magdalene, like all saints, has her place in altarpieces and other church paintings, where she appears most frequently in scenes of Christ's crucifixion and entombment. Images like these could also be painted on a small scale for private viewing and devotion. A particularly beautiful example is Annibale Carracci's *The Dead Christ Mourned* or '*The Three Maries*' of about 1604 [39].

40. Detail of 39, Mary Magdalene

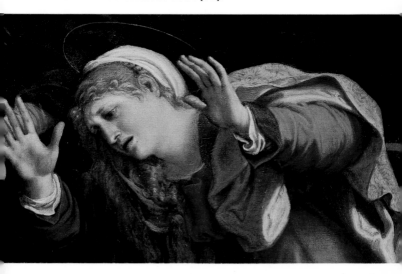

The subject was inspired by medieval meditational texts that introduced a scene of lamentation between the biblical accounts of Christ's death on the cross and his burial. Unusually, Annibale depicts only women mourners, and implies a slightly earlier moment, also often represented in art: the Pietà – the Virgin taking leave of her Son, laid across her lap in death as he had lain in sleep as an infant. Here, Mary faints with grief. She falls back, and Christ's body slides off her lap onto the ground. Two of the women – probably Mary, the mother of James, and Mary Salome, who will return to the tomb on Easter morning with Mary Magdalene (Mark 16:1) – hurry to her aid, distressed on her behalf. The Magdalen herself, younger and richly dressed, her golden hair loose, has eyes and tears only for her lord [40]. Her face is,

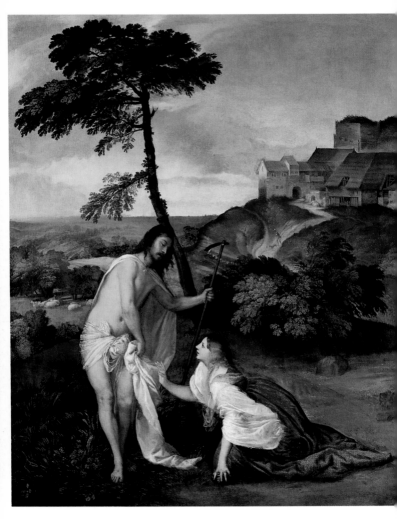

41. Titian,
Noli me Tangere,
about 1515.
109 x 90.8 cm.

literally, an ancient mask of tragedy. The Virgin is one flesh with her Son, the mystical texts tell us: she experiences his sufferings body and soul, and almost dies with him. Mary Magdalene's sorrow is different, more like the anguish of a woman who survives the death of her lover. In the imagery of Christ's death, she is the supreme heroine of earthly love and loss.

But, as Neil MacGregor writes in his meditation on Titian's painting of the risen Christ appearing to the Magdalen [41, 42], 'a lord who cannot be touched is a lord who can never be taken away'. Losing the man Jesus, whose body she can never again touch, Mary Magdalene finds God, and her own immortal soul.

Though representing a psychological and meta-physical drama of universal import, Titian depicts the Magdalen as a contemporary Venetian courtesan. In shock and deep mourning, she has come with her jar of precious ointment to anoint Jesus's body for the last time, yet she is dressed as if going out to dinner – the kind of party we know the artist enjoyed, with game, artichokes, beautiful women, wine and song. This is of course intended to evoke the occasion when, as a sinner, she anointed Jesus's feet with her hair, and to make the moment shown here even more poignant.

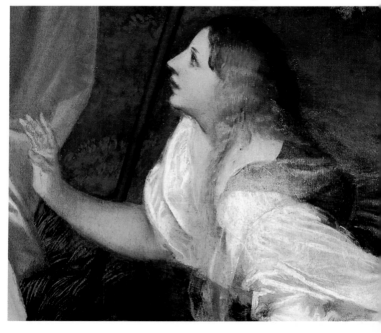

But it is also intended, I cannot help but feel, to make the Magdalen, and thus the picture itself, more allur-ing to the viewer, particularly a male viewer.

42. Detail of 41, Mary Magdalene

Some decades later, Savoldo, a Brescian artist who also worked in Venice, painted this very different image of Saint Mary Magdalene approaching the Sepulchre [43].

'The first day of the week cometh Mary Magdalene early, when it was yet dark, unto the sepulchre ...' (John 20:1). The picture is only slightly smaller than Titian's [41], but it is almost entirely filled with the figure of Mary. Savoldo focuses on her in 'close-up', precisely like a modern film director who wishes view-ers to share a protagonist's feelings. Behind her we

43. Savoldo,
*Saint Mary
Magdalene
approaching the
Sepulchre,*
about 1530.
89.1 x 82.4 cm.

see the yawning darkness of Christ's sepulchre, displaced from the countryside near Jerusalem, perhaps to Venice's cemetery island of San Michele; in the distance the sun rises over the lagoon. More suitably dressed than Titian's Magdalen, Savoldo's figure is wrapped in a cloak – a cloak, however, of shimmering satin, whose virtuoso depiction is a hallmark of the painter's work. She has set down her jar of ointment by her side.

Savoldo may be picturing a specific moment in the Gospel text. Mary, having found the tomb empty, alerts Peter and the other disciples. After their return home, she remains alone by the sepulchre, weeping, convinced – even after speaking to two angels sitting

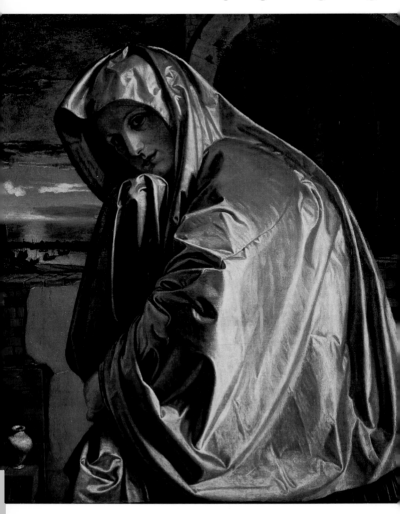

in the tomb – that Jesus's body has been taken away and hidden.

> *And when she had thus said, she turned herself back, and saw Jesus standing, and knew not that it was Jesus.*
> *Jesus saith unto her, Woman, why weepest thou? whom seekest thou? She, supposing him to be the gardener, saith unto him, Sir, if thou have borne him hence, tell me where thou hast laid him, and I will take him away.*
> *Jesus saith unto her, Mary. She turned herself, and saith unto him, Rabboni: which is to say, Master.* (John 20:14–16)

Mary 'turns herself' twice: first to speak to the gardener, then in recognition of her Master's voice. Her sorrow is tempered first by hope, then dispelled by tentative, half-disbelieving joy – and it is these transient expressions that, I believe, animate her face in Savoldo's painting.

The spectator is meant to share in the drama of the revelation to Mary: Jesus Christ has truly risen from the dead. But in turning herself towards us, the Magdalen is, by definition, looking into the eyes of a male viewer. We see her from Christ's point of view.

But there is another sense in which Savoldo's picture may have been designed to appeal to a male gaze – the gaze of someone not necessarily disposed to devotion or familiar with the Gospel text. When all is said and done, Savoldo shows a beautiful woman, luxuriously dressed, beckoning. Because images are so much more ambiguous than words, the painting allows itself to be read as a seductive invitation, possibly to an amorous encounter.

Images of the Magdalen living out the rest of her life in penitence in the wilderness of southern France, according to later legend, follow a similar pattern. As her fine clothes rotted away, it is said, her hair grew miraculously long to preserve her modesty. In a famous statue in Florence, the fifteenth-century sculptor Donatello showed her as an old woman, nearly toothless and scrawny from fasting, dressed only in abundant locks of hair. But by the sixteenth century collectors' pictures of the penitent Magdalen were less austere. A painting of about 1518, attributed

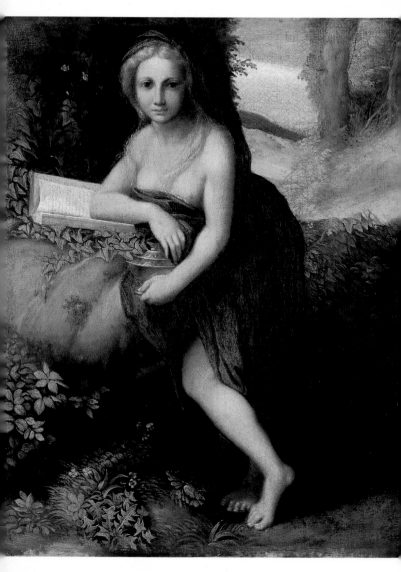

44. Attributed to Correggio, *The Magdalen*, perhaps about 1518–19. 38.1 x 30.5 cm.

to Correggio and known in several versions, makes the point [44]. In the bloom of youth, blond hair loose but not yet grown to cover her body, the saint artfully arranges what remains of her cloak to reveal her breasts and legs. She holds her attribute, the pot of ointment, and has a book propped up beside her, but she stares appealingly at the viewer with dark, lustrous eyes, a faint smile on her lips. Her pose and appearance disturbingly recall those of Venus, goddess of love and beauty, in Correggio's mythological picture, '*The School of Love*' [45].

45. Correggio, *The School of Love*, about 1525. 155.6 x 91.4 cm.

46. Adriaen Ysenbrandt, *The Magdalen in a Landscape*, perhaps about 1510–25. 40 x 31.1 cm.

The penitent Magdalen has another aspect, hinted at in Correggio's picture but more fully developed in northern Europe than in Italy, with its memories of pagan sculpture. She belongs to that small elite of women who may be portrayed reading. Like the scholarly Saint Jerome, she brings a bible with her into the wilderness [46]. She also reads indoors [47, 48]. Rogier van der Weyden's painting of about 1435 is a fragment from an altarpiece, but the image was soon adapted for private viewing [49].

When the Virgin Mary is shown with a book, she is to be understood as reading one of the Old Testament

prophecies of her role in the history of Salvation, such as Isaiah's: 'Behold, a virgin shall conceive, and bear a son, and shall call his name Immanuel' (Isaiah 7:14) [47]. Her reading symbolises her acquiescence to God's plan. The Magdalen's reading is meant to be contemplative and penitent. She has turned from the world to the Word of God. But does this make Figure 49, and its many versions and variants, suitable devotional pictures for women viewers?

47. Master of Liesborn, *The Annunciation*, probably 1470–80 98.7 x 70.5

Possibly. Yet there is to my eye something transgressive about this image as well. The elegant youthful Magdalen, bejewelled and dressed in the latest style, with red lips and downcast eyes, may be demure, but she does not appear to be particularly penitent. She owns a costly illuminated and lavishly bound manuscript. In many households, her reading might have seemed a form of ostentatious idleness, the ornament of one who neither toils nor spins. She seems to me to represent yet another face of Woman, as constructed in a male-dominated society ambivalent in its feelings towards women.

48. Rogier van der Weyden, *The Magdalen Reading*, probably about 1435. 62.2 x 54.4 cm.

49. Ambrosius Benson, *The Magdalen Reading*, about 1525. 41 x 36.2 cm.

PROTECTORS
AND INTERCESSORS

SAINTS IN NEED, SAINTS INDEED

In addition to their role as intercessors, protectors and role models for communities, institutions, families and individuals, saints could be called upon

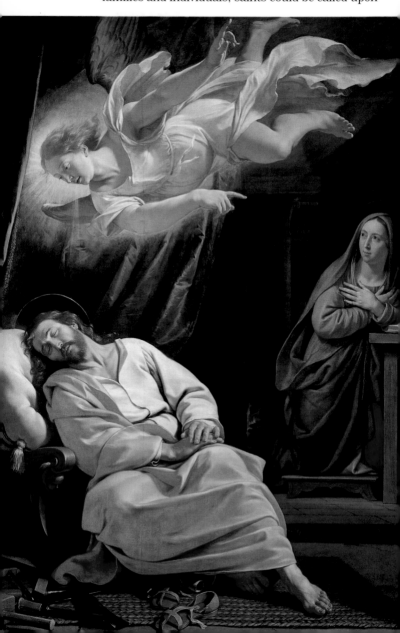

by those in need of help. This remains perhaps their most familiar and popular function. Many people, even in Protestant or mainly secular countries, recall that Saint Jude – the apostle also known as Thaddeus or Lebbaeus – is the defender of last resort in lost causes, although we don't know why this should be so. According to the Golden Legend, he was martyred in Persia after performing many extraordinary miracles, and baptising 'more than sixty thousand people, not counting children'.

Other saints' legends clearly show why they have been invoked for particular afflictions. The principle is exactly the same as when choosing saints to be the patrons of particular professions and trades: an affinity is found with the saints' way of life, or with the circumstances of their martyrdom. Cosmas and Damian, doctors, are patrons of physicians (and the Medici family) [Figures 12, 23 and pages 21, 35]; the apostle Luke, another doctor but also the only known Sunday-painter saint, is more often venerated by painters [Figure 13, page 21]. Jesus's foster-father, Joseph the carpenter (Matthew 13:55; Mark 6:3) naturally became the carpenters' patron saint, which is why Philippe de Champaigne spreads a modern assortment of wood-working tools at his feet in an altarpiece dedicated to him [50, 51].

50. Philippe de Champaigne, *The Vision of Saint Joseph*, about 1638. 208.9 x 155.6 cm.

51. Detail of 50.

A more poetic tradition accounts for Saint Cecilia's patronage of music and musicians [52]. A real person of this name was buried in the early Christian Roman catacomb of San Callisto. The legendary Saint Cecilia, a beautiful girl of patrician rank, was betrothed to a young pagan, Valerian. On her wedding day she told him that she had consecrated her virginity to God, and persuaded him to be baptised, along with his brother. All three were put to death as obstinate Christians. A sixth-century hymn in her honour

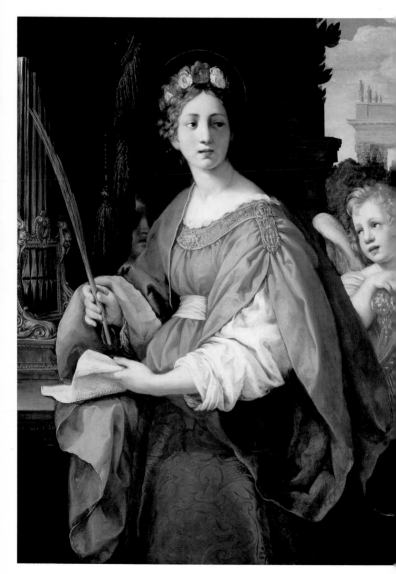

speaks of Cecilia singing to God 'in her heart' while musicians played at her wedding, and it is this touching particular with which she is forever associated. She is usually, as in Figure 52, represented with a portative organ. The anonymous German painter of a small domestic triptych altarpiece, probably made in Cologne around 1480, adds a further refinement [53]. On Saint Cecilia's right hand, gloved like that of a falconer, there perches a bird: Nature's musician, singing God's praises as Cecilia did at her wedding, and as all human musicians ought at all times.

53. Workshop of the Master of the Saint Bartholomew Altarpiece, detail of Saint Cecilia, from *The Virgin and Child in Glory with Saints*, about 1512. 36 x 59.2 cm.

54. Style of the Master of the Female Half-Lengths, *Saint Christopher carrying the Infant Christ,* about 1525–50 24.8 x 54.6 cm. Detail

The same kind of association, often first made memorable through images, determined which saints to call on when in need. Even today, the dashboards of many cars, and the manly chests of many truck drivers, are decorated with medallions of Saint Christopher. He was the giant ferryman who, after his conversion by an elderly hermit, devoted his life to helping people cross a raging torrent, and once carried the Infant Christ himself. His role as patron of

travellers is made obvious in this sixteenth-century Netherlandish picture, where the torrent of legend becomes a sea dotted with ships [54]. Travelling remains a perilous business, and although not every medallion may testify to genuine faith, there remains the uneasy feeling that putting oneself under a saint's protection can do no harm. Even atheists, it used to be said, pray in the trenches.

55. Carlo Crivelli,
*The Demidoff
Altarpiece*, 1476.
148.6 x 63.5 cm.
Detail of
Saint Lucy

Popular devotion like this is akin to sympathetic magic, that combats like with like. Another early Christian martyr, Saint Lucy, was said to have been loved by a pagan for the beauty of her eyes. Rather than give up her virginity, she plucked her eyes out

to send to her rejected suitor (and was later denounced by him as a Christian, and put to death). Her somewhat gruesome attribute is a pair of eyes carried on a dish [55], and she has consequently been invoked for help by people with diseases of the eyes.

The hermit Saint Anthony Abbot was subject to temptations and tormented by demons who tore his flesh with their claws [56]. He became the patron of

56. Annibale Carracci, *Christ appearing to Saint Anthony Abbot during his Temptation,* about 1598. 49.5 x 34.4 cm.

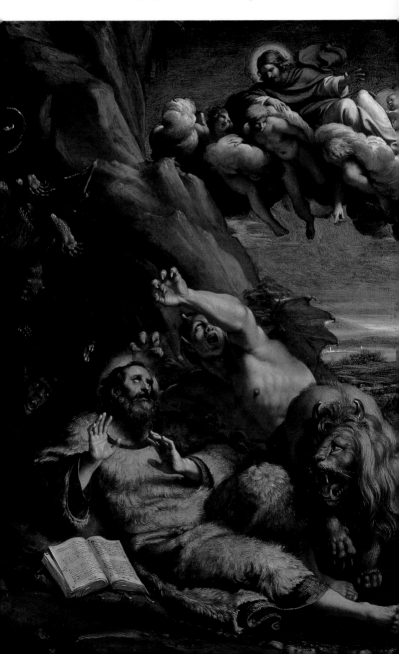

those afflicted with skin diseases, especially leprosy
and ergotism. This painful, often fatal illness, that
produced hallucinations as well as burning and
itching, is caused by a fungus affecting rye, once the
staple grain of northern Europe. Known as Saint
Anthony's Fire, ergotism was rampant throughout
Germany, the Netherlands and much of France. A
religious order founded in Anthony's name was dedi-
cated to its treatment, using, among their various
therapies, balms and ointments derived from medici-
nal plants but made especially effective through
contact with the saint's relics.

The greatest ill that threatened Europe, however,
was bubonic plague, the dreaded Black Death: a
bacterial disease that originated in Asia and, as we
now know, was carried by the fleas of black rats. It
first reached the West in 1348, killing between one
third and one half of the population in a matter of
months. Sporadic outbreaks continued to occur for
many centuries; there were no effective remedies. Not
surprisingly, especially since the cause of so great a
disaster was thought to be the wrath of God, super-
natural aid was sought.

Pagan Greeks and Romans had already drawn an
analogy between the vindictive arrows of the gods
and sores that afflicted the sick. So it was natural for
Christians to invoke Saint Sebastian – martyred,
though not killed, with arrows – against the plague,
one of whose first symptoms was a swelling, or bubo,
of the lymph nodes, which developed into festering
wounds. Such invocations often added the promise,
or vow, to thank the saint for his successful inter-
cession. A late fifteenth-century Sienese painting
may have been commissioned as just such a 'votive'
thank offering by the brothers of the Misericordia, a
charitable confraternity dedicated to the care and
burial of plague victims [57]. Saint Sebastian,
bristling with arrows, is accompanied by Saint
Fabian, an early Christian pope and martyr who
shares his feast-day. Two members of the brother-
hood kneel at their feet, dressed and hooded in black
and veiled against contagion.

At about the same time as this panel was painted
in Siena, one of the most famous altarpieces of the
Renaissance was completed by the Pollaiuolo brothers
for the Oratory of Saint Sebastian in Florence, where

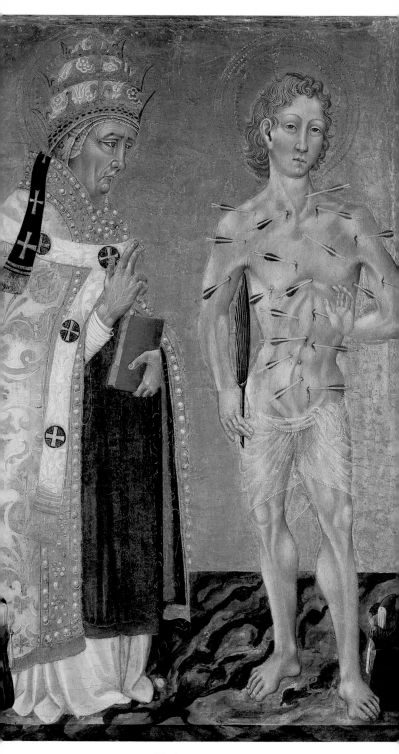

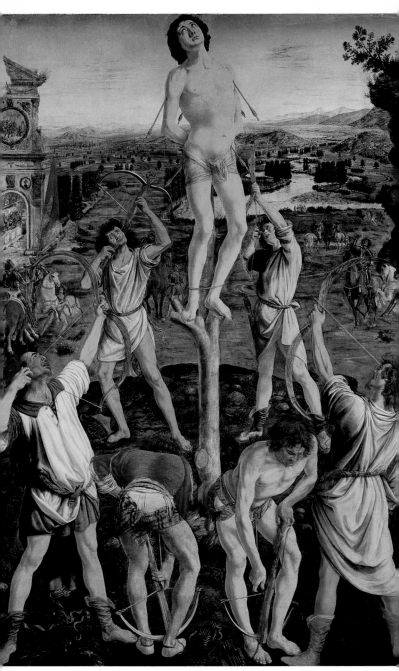

58. Antonio and Piero del Pollaiuolo, *The Martyrdom of Saint Sebastian*, completed 1475. 291.5 x 202.6 cm.

the precious relic of the martyr's arm bone was kept [58]. Unlike their Sienese contemporary, the avant garde Florentines depicted the dramatic scene of the saint's martyrdom, the better to demonstrate their new-fangled mastery of anatomy, geometry, perspective, landscape, and ancient architecture. The altarpiece's single-panel rectangular format is an innovation, as is the use of oil paints. It is chastening for a present-day viewer to compare the Pollaiuolos' 'modern' masterpiece with Giovanni di Paolo's old-fashioned panel, and realise that they express fundamentally the same concerns and preoccupations, if not the same artistic ideals.

59. Detail of 58.

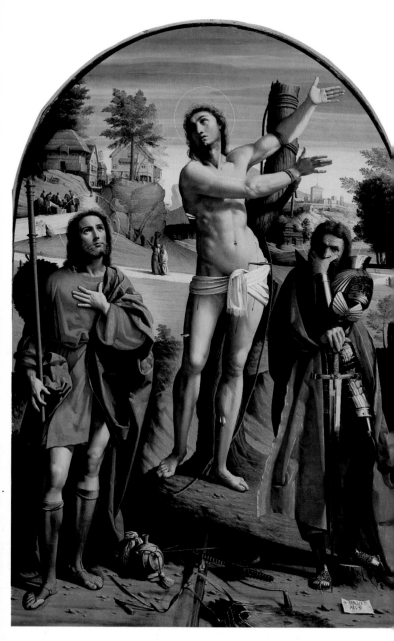

60. Ortolano,
*Saint Sebastian
and Saints Roch
and Demetrius,*
about 1520.
230 x 154.9 cm.

OPPOSITE
61. Detail of 60.

By this date, however, Saint Sebastian was often pictured in the company of another 'plague saint', Roch, Rock or Rocco – a fourteenth-century pilgrim who contracted the plague while nursing the sick during an epidemic in northern Italy. They appear together in innumerable altarpieces commissioned either during or after an epidemic. Many were found

in cities, and many others in specially built votive churches and chapels on the pilgrimage and trade routes along which the plague also travelled.

In an early sixteenth-century example from near Ferrara [60], Sebastian is raised in the centre, tied to a tall tree stump. Beneath is a crossbow abandoned by the would-be executioners, and an inconspicuous quartet of arrows pierce his flesh. On his right stands Saint Roch, leaning on his pilgrim's staff, his bundle of food and pilgrim's flask at his feet [61]. His jerkin is asymmetrically cut, the better to show off the bubo above his left knee. His other traditional attribute, a companion dog, has been omitted, perhaps because the artist or his clients felt the animal would have been an indecorous presence above the altar. Balancing Roch on Sebastian's left is a thoughtful Saint Demetrius, an early Christian warrior saint and martyr, famous in the Eastern Church but so little known in the West that he is identified by a name tag.

It is almost impossible, looking at this calm trio so strangely, yet so convincingly gathered together in a peaceful landscape, within sight of indifferent passers-by, to reconstruct the tormented circumstances in which this altarpiece, with its two plague saints, must have been commissioned. Suffering, death and the fear of death, the grief and guilt and gratitude of survivors, are here sublimated into an image of serene trust and hope.

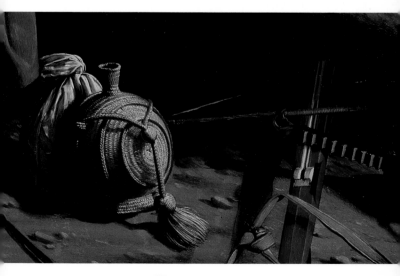

Real or legendary, the saints and martyrs assumed into Heaven remain among us on earth, in millions of images that show us whom to call on for help when our own troubles are too great to bear – or too trivial to bother the Almighty with. They mark out the feasts of the year, the years and seasons of our lives, our allegiances and duties. Though not to be worshipped as idols, they have inherited much of the appearance and nature of pagan divinities: some beautiful and alluring, others stern; some noble, others lowly [62].

Like the ancient myths, the stories of their lives and deaths make exciting reading, yet it is mainly through images that they teach us what it means to believe, to sin and to repent, to suffer and rejoice, to endure or do battle, to live in solitude or in fellowship with others – or simply to enjoy images. They remind us of who we are, and what we can become, of the limits and potentials of our own nature. We can, as we wish, view them as projections of our own human needs, or as evidence of the grace of God.

FURTHER READING

The main source of information about earlier saints is *The Golden Legend*, available in various editions, including:

Jacobus de Voragine, *The Golden Legend*, Princeton University Press, 2 vols, 1995

Jacobus de Voragine, *The Golden Legend* (selections), Penguin Books, 1998

For further information about saints in National Gallery paintings, see:

D. Bomford, J. Dunkerton, D. Gordon, A. Roy and J. Kirby, *Art in the Making: Italian Painting before 1400*. National Gallery Company, London, reprinted 2000

J. Dunkerton, S. Foister, D. Gordon and N. Penny, *Giotto to Dürer: Early Renaissance Painting in the National Gallery* Yale University Press, New Haven and London, in association with National Gallery Publications, 1991

GENERAL:

D. Attwater, *The Penguin Dictionary of Saints*, 3rd revised edn, Penguin Books, 1995

F. L. Cross and E. A. Livingstone, *The Oxford Dictionary of the Christian Church*, 3rd revised edn, Oxford, 1997

D. H. Farmer, *The Oxford Dictionary of Saints*, 4th revised edn, Oxford, 1997

Bible and the Saints, Flammarion Iconographic Guides, 1994